EDINBURGH
HISTORY TOUR

First published 2018

Amberley Publishing
The Hill, Stroud,
Gloucestershire, GL5 4EP
www.amberley-books.com

Copyright © Liz Hanson, 2018
Map contains Ordnance Survey data
© Crown copyright and database
right [2018]

The right of Liz Hanson to be
identified as the Author of this work
has been asserted in accordance with
the Copyrights, Designs and Patents
Act 1988.

ISBN 978 1 4456 5607 6 (print)
ISBN 978 1 4456 5608 3 (ebook)

British Library Cataloguing in
Publication Data.
A catalogue record for this book is
available from the British Library.

Origination by Amberley Publishing.
Printed in Great Britain.

INTRODUCTION

The history of Edinburgh is not for the faint-hearted. Between the foundation of the royal burgh in 1130 and the cosmopolitan city of today, there are nearly nine centuries packed with drama, battles, uprisings and religious convolutions interlaced with innovation, discovery, achievement and creativity. Much of the history is stitched together with a jagged thread – that of the struggle against domination by England.

Volcanic eruptions millions of years ago, followed by sheets of ice scouring away all but the hardest rocks, were the natural events responsible for the topography of Edinburgh. The plug of Castle Rock and the tail of the Royal Mile formed the very heart of the city.

David I built the castle at the highest vantage point, while at the lower end of this geological formation he founded Holyrood Abbey and the Old Town evolved between these two points. During incursions by the English in the thirteenth century Edinburgh Castle was captured, although it was regained by Robert the Bruce after his victory at Bannockburn in 1314.

It is hard to imagine that 12,000 people lived in the confines of the Royal Mile and its closes in early sixteenth century, but it explains the height of the tenement buildings – the city walls prevented expansion horizontally, so 'medieval high-rise' was the only solution. As the

numbers of residents together with their livestock (and associated waste) increased, and with no piped water, living conditions were dire.

The sixteenth century began with the devastating defeat and death of James IV at the Battle of Flodden, followed in the 1540s by 'the rough wooing' – widespread sacking and burning in Edinburgh and the Borders on the orders of Henry VIII. Shortly after this, the religious upheaval of the Reformation took place, led by the Protestant reformer John Knox, who railed against the Catholic Mary, Queen of Scots in 1560.

The Scottish parliament moved from the decrepit Old Tolbooth to a purpose-built Parliament House in 1640 thanks to Charles I and sixty-seven years later joined with the English parliament under the Treaty of Union of 1707.

Despite ongoing political and religious strife, Edinburgh's culture began to flourish during the Scottish Enlightenment, particularly in law and medicine but also in philosophy, geology, architectural design and writing. During this time of improvement and innovation, however, the chronically overcrowded Old Town was at breaking point and a proposal was put to the town council to create a New Town on the other side of the Nor Loch valley. In the 1770s, North Bridge was built to cross the chasm, the loch was drained, and the first phase of James Craig's winning design was started. The new houses were classical, elegant and highly desirable, resulting in an exodus from the grimy tenements on the High Street, heralding in a novel, peaceful era in the history of Edinburgh. Both Old and New Towns are now UNESCO World Heritage sites.

KEY

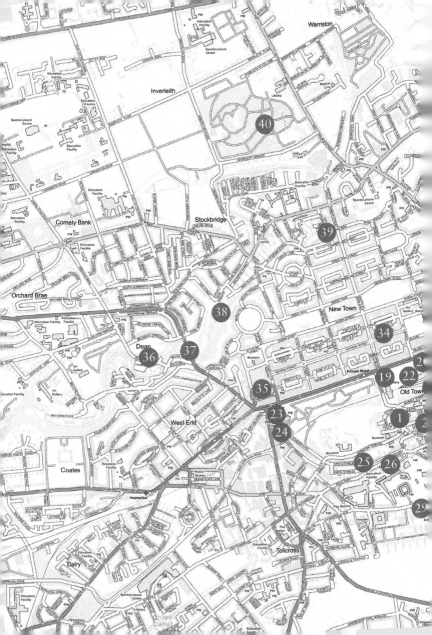

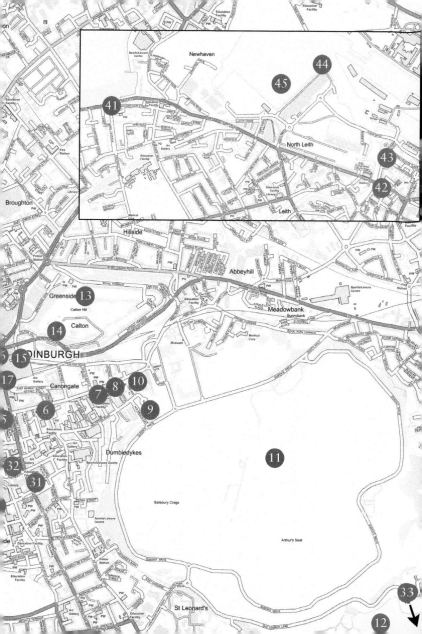

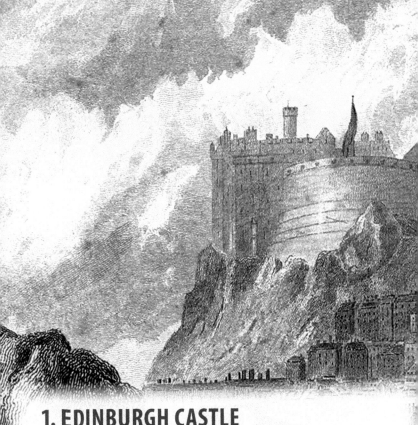

1. EDINBURGH CASTLE

This fortification seems to grow out of a steep-sided plug of volcanic rock, making the castle virtually impenetrable other than by the entrance on Castlehill. The elevated location, with extensive views, made the stronghold ideal for defending the surrounding Lowlands. In 1386, David II added a five-storey tower, which was destroyed in 1573 by the Protestant army of Elizabeth I during 'The Lang Seige'. The half-moon battery is built on its foundations. The oldest surviving structure at the castle is the early twelfth-century St Margaret's Chapel.

2. LAWNMARKET

The slope of the Royal Mile between the castle and Holyrood has three named sections: Castlehill is at the top; Canongate at the lower end; and Lawnmarket in the middle where market trading took place, mostly from locked stalls known as luckenbooths. They were clustered around and adjacent to St Giles' Cathedral, making the narrow thoroughfare very noisy and congested.

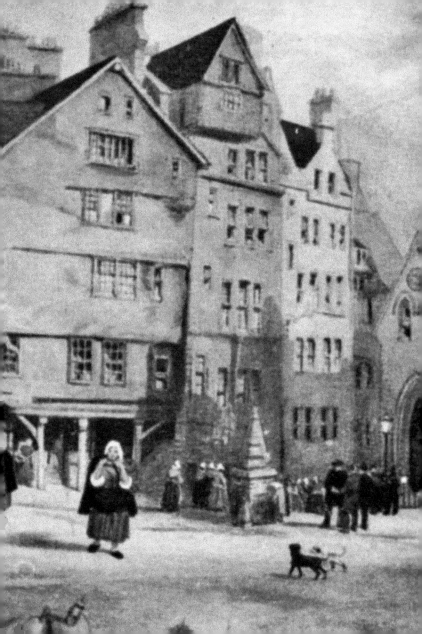

3. OLD TOLBOOTH

This was built in 1561 as the town hall and meeting place for both parliament and the Court of Session until 1640, when Parliament House was built, and it became the city's jail. It was notorious for the deplorable conditions endured by the prisoners and was a destination feared by all. In 1785, a platform was added on which executions took place. When it was demolished in 1817, Walter Scott, who collected Edinburgh memorabilia, took the Old Tolbooth door to Abbotsford House. He named it 'Heart of Midlothian', now marked in cobbles on the site.

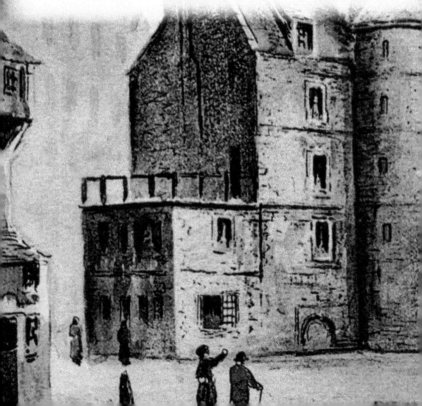

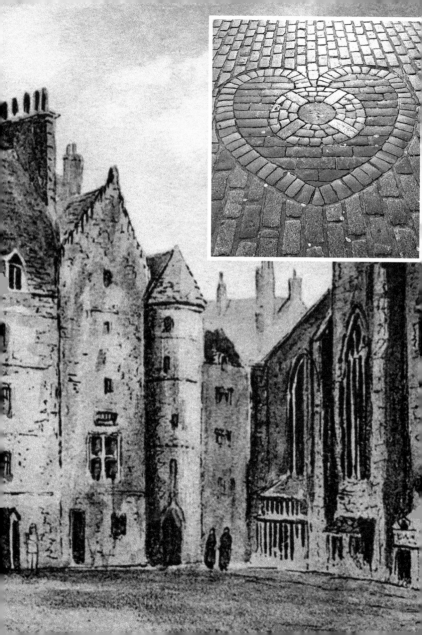

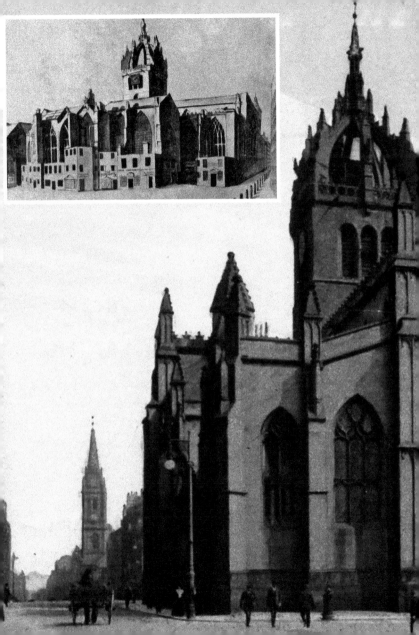

4. ST GILES' CATHEDRAL

This was the parish church of Edinburgh until the Reformation, and the land on its southern side used as a burial ground. Only fragments of the original building remain.

The first simple church on this site was founded in the early 1100s, dedicated to St Giles, patron saint of lepers, nursing mothers and the lame. The Gothic architecture dates from the fourteenth century when wealthy Edinburgh merchants paid for rebuilding after the original one was burned by the English. Over the next 150 years, additional altars, side chapels and aisles embellished the church, which was made into a cathedral by Charles I in 1635. The inset drawing from 1771 shows the luckenbooths.

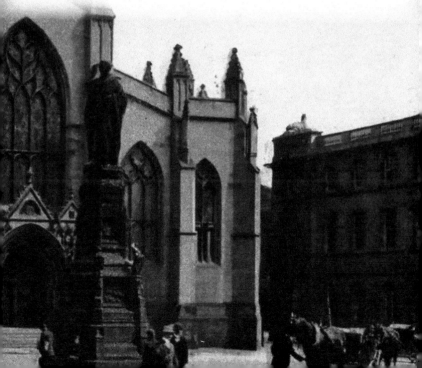

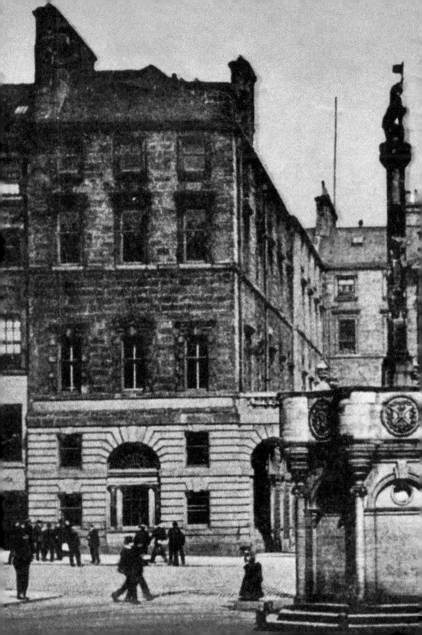

5. MERCAT CROSS

The gathering place for royal and public proclamations to the citizens sits just behind St Giles', on the edge of Parliament Square, although the original site was a few yards away, now represented by an octagon of cobble stones. The fifteenth-century shaft was replaced in 1970 but the capital dates from that time. The cross was removed completely in 1756 and stored at Drum House until William Gladstone paid for it to be reinstated in the High Street. Walter Scott procured some of the sculpted medallions for his garden at Abbotsford.

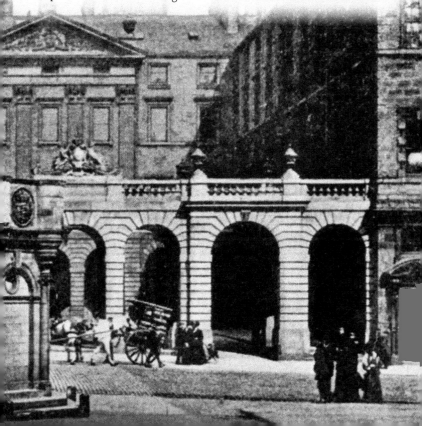

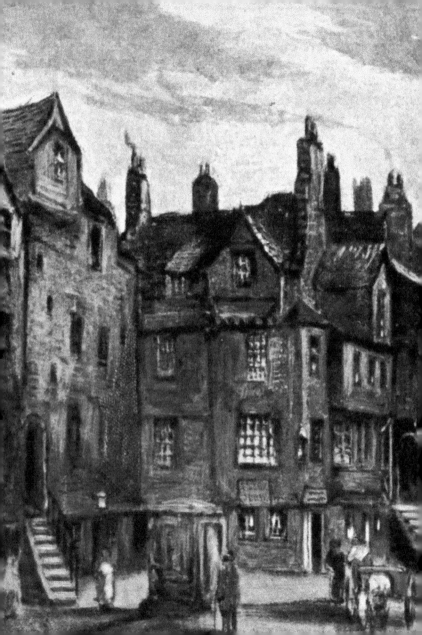

6. NETHERBOW

The eastern entrance to the medieval city from Canongate was through the port, or gate, of Netherbow where a toll was charged. The poorer residents were trapped inside the town, unable to afford the re-entry charge, hence the name of the nearby pub The Worlds End. Netherbow was demolished in 1764, but its clock can be seen on the Dean Gallery. The fifteenth-century house on the left was the home of the Protestant reformer John Knox. He became minister of St Giles' after the Reformation and died in 1572.

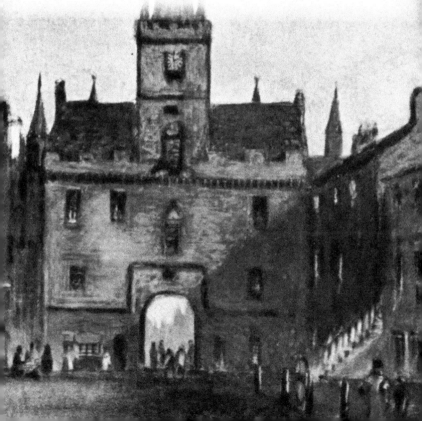

7. CANONGATE

This burgh, founded by David I for the Augustine monks of Holyrood Abbey, remained independent from Edinburgh until 1856. The distinctive tolbooth of 1591 has survived – unlike the Old Tolbooth of Edinburgh – but is utilised as The People's Story Museum. Many Covenanters were incarcerated here between 1661 and 1688. Holyrood Abbey was used as the parish church up until the Reformation, after which, in 1688, Canongate Kirk was founded.

Old Playhouse Close in Canongate was the location of the first public playhouse after the Reformation. The buildings are seventeenth century.

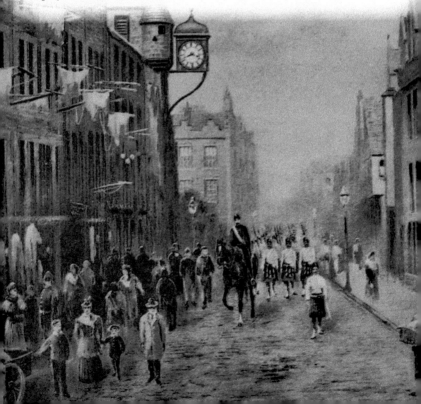

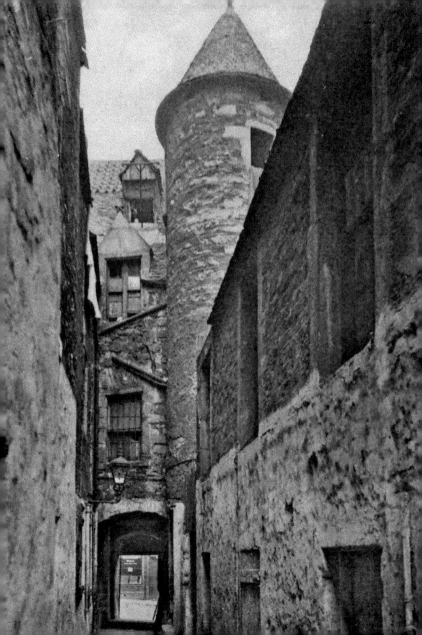

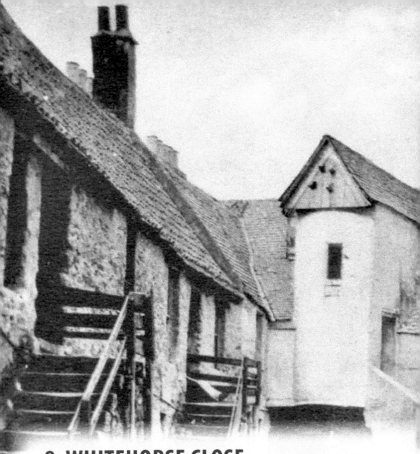

8. WHITEHORSE CLOSE

This mews at the foot of Canongate was used to stable horses from Holyrood in the sixteenth century before these houses were erected in the 1600s. It is named after 'the white horse of Hanover', reputedly the favourite steed of Mary, Queen of Scots. Three hundred years later, the properties, which had become dilapidated, were renovated in the 1960s, transforming the close into the most attractive in the Royal Mile.

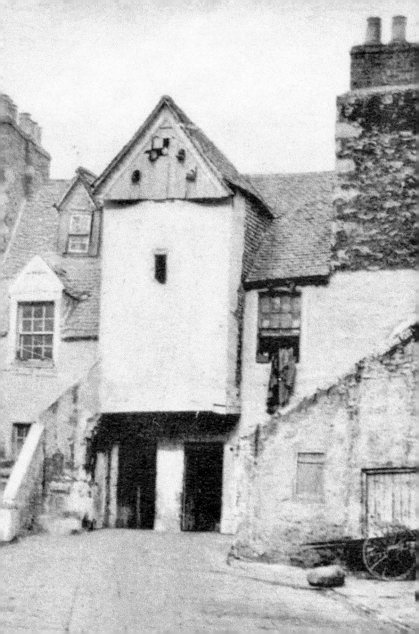

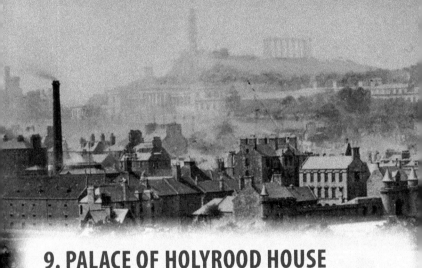

9. PALACE OF HOLYROOD HOUSE

The abbey was founded in 1128 by David I, but it wasn't until 1498 that James IV extended the royal quarters there. The comfortable palace was preferred by royalty to the cold accommodation at the castle, and therefore was a target for the English over the next two centuries, necessitating frequent repairs. Eventually, during the reign of Charles II (1660–85), a complete reconstruction was undertaken to create the palace seen today. It is the official residence of the British monarchy in Scotland. The Scottish Parliament building is on the site of the tenements on the left of the photograph.

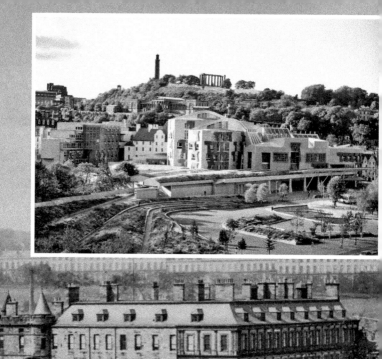

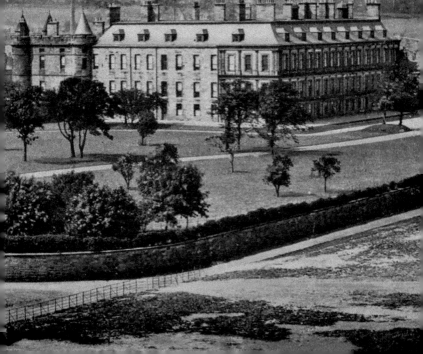

10. HOLYROOD ABBEY AND QUEEN MARY'S BATH HOUSE

The nave of the abbey ruins is the site of the original twelfth-century ecclesiastical building founded by David I and used as the parish church by parishioners of Canongate Burgh. In 1687 James VII evicted the Protestant congregation in order that he could restore it as the chapel for his revived Order of the Thistle, but within twelve months he was exiled and the building ransacked. The roof collapsed in 1768.

This curious asymetrical building in the grounds of the Palace of Holyrood House is thought to have been a lodge or pavilion, not, as folklore states, the place where the queen bathed in sweet white wine! It was restored in 1852.

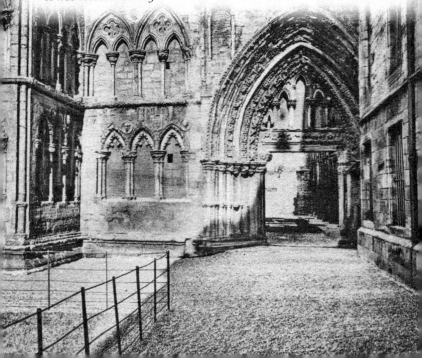

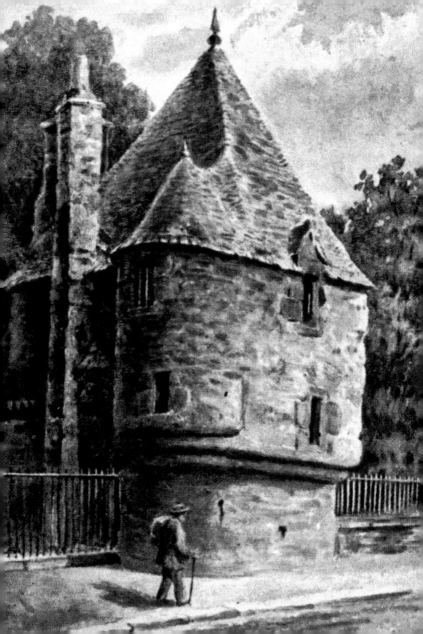

11. HOLYROOD PARK

The 650-acre space around Holyrood includes the volcanic plug of Arthur's Seat, the sheer Salisbury Crags, heathland and pasture and in medieval times was a royal hunting park. In 1541 James V enclosed the land with a stone wall. Queen Victoria and Prince Albert were so enamoured with the park that they had a road laid around the circumference – known as Queens Drive – as well as creating two artificial bodies of water: Dunsapie Loch and St Margaret's Loch. Overlooking the latter are the ruins of St Anthony's Chapel, whose history is not known. Sheep grazed the grassy slopes in the park right up until 1977.

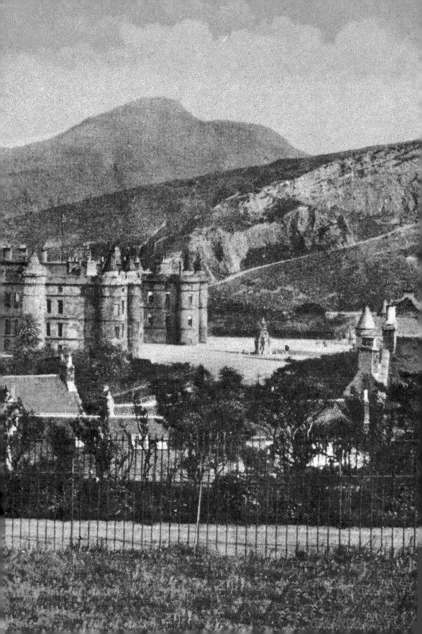

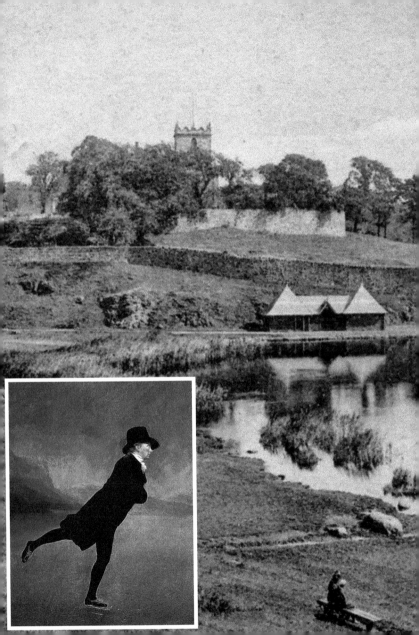

12. DUDDINGSTON LOCH

The loch and village of Duddingston lie just outside the southern wall of Holyrood Park. In 1794, Edinburgh Skating Club was founded, the first of its kind in the world and immortalised by the painting *The Reverend Robert Walker Skating on Duddingston Loch* by Sir Henry Raeburn. The local Sheep Heid Inn was patronised by Mary, Queen of Scots, and her son, James VI, gave the innkeeper a snuffbox decorated with a ram's head.

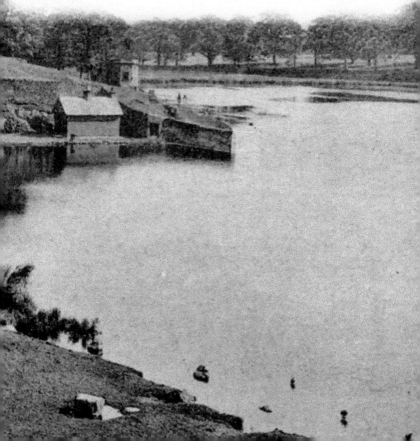

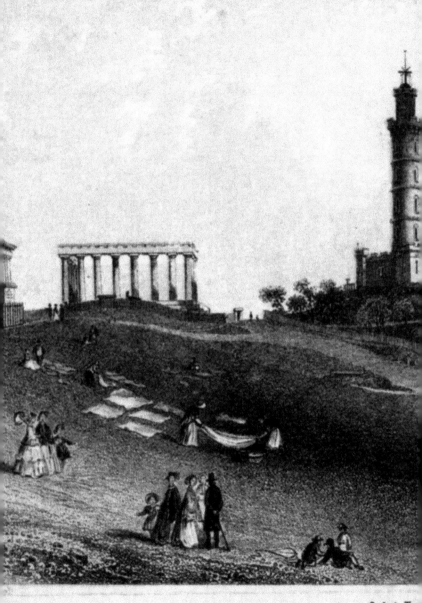

CALT

13. CALTON HILL

At the eastern end of Princes Street is the modest but prominent feature of Calton Hill, eye-catching because it is adorned with an array of disparate structures. The oldest is Old Observatory House (1776), designed by James Craig, who was responsible for the layout of New Town. The City Observatory (1818) and the unfinished National Monument, both designed by the architect William Playfair, reflect the Greek Revival era and contributed to Edinburgh's sobriquet 'Athens of the North'. Nelson's Monument and Dugald Stewart's Memorial are notable.

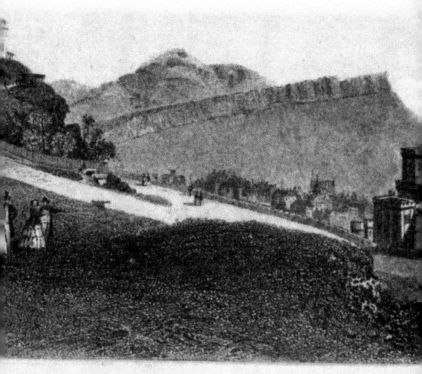

ILL.

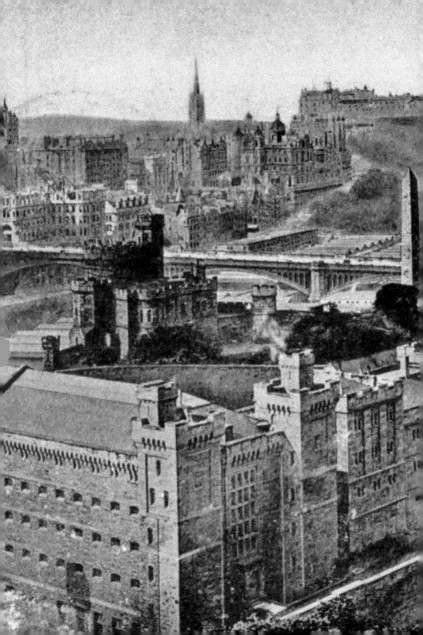

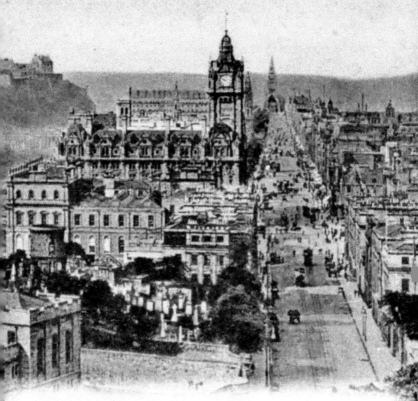

14. VIEW FROM CALTON HILL

The jail that replaced the Old Tolbooth was built below Calton Hill
between 1791 and 1796. It was designed by Robert Adam and the
Gothic style was controversial with residents, although favoured
by Walter Scott. The building – apart from the castellated tower of
Governer's House – was demolished in 1935 to make way for the art
deco bulk of St Andrew's House, which is the headquarters of the
Scottish government.

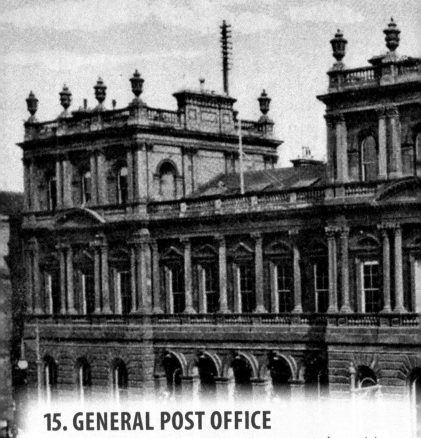

15. GENERAL POST OFFICE

The east end of the new Princes Street attracted prestigious establishments, being the important junction of North Bridge, Leith Walk and Waterloo Place. The Register House of 1774, on the north-west corner, which is fronted by the statue of the Duke of Wellington on horseback, is still functioning today. Diagonally opposite, on the site of Theatre Royal (1769–1859), the massive General Post Office was built in 1861. The edifice was vacated by this service in 1995 and the interior has been converted into a modern business space.

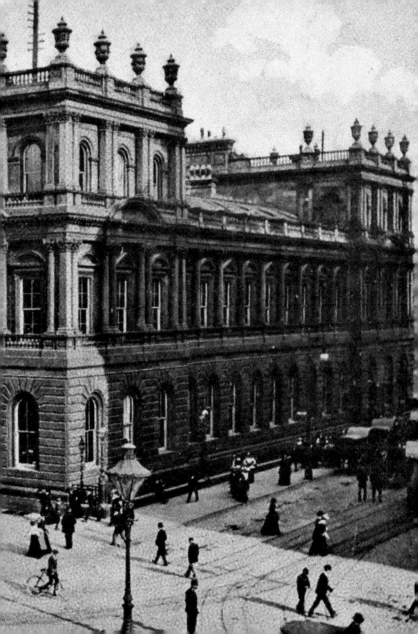

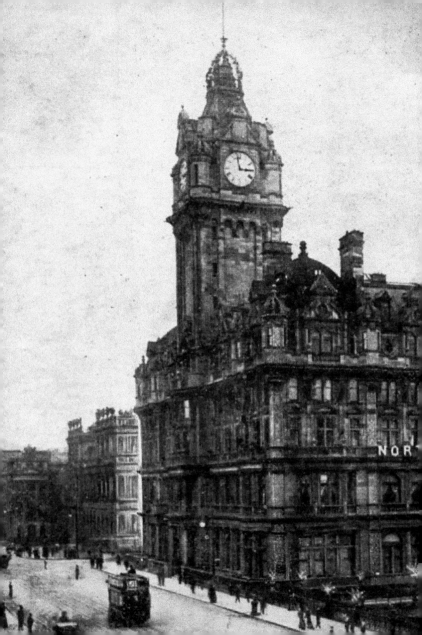

16. NORTH BRITISH HOTEL

Opposite the Italian Renaissance architecture of the GPO, the Scottish baronial Victorian North British Hotel bookended North Bridge and Princes Street. It was built adjacent to Waverley station in 1902 as the railway hotel for the North British Railway. The large clock is famously three minutes fast to give passengers a little extra time to catch their train.

In 1988, as part of refurbishment, some of the original ornate balconies were removed and it was renamed The Balmoral. It is now owned by Rocco Forte.

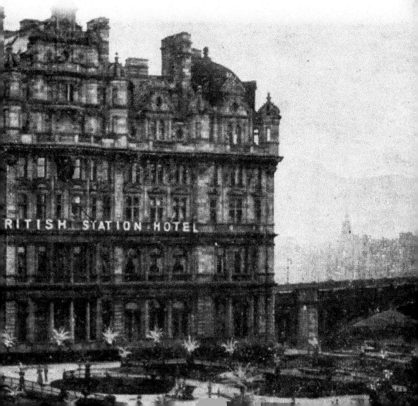

17. NORTH BRIDGE

The Old Town had become so overcrowded and insanitary by the 1760s that the plan to build a New Town to the north was wholeheartedly embraced by all. The first stage was to span the valley of the Nor' Loch by a triple-arched bridge, designed by William Mylne. The prototype partially collapsed but was successfully rebuilt, widened and strengthened; it was a seminal moment in Edinburgh's expansion.

18. WAVERLEY STATION

This was created from the amalgamation of three existing but separate stations. North Bridge station (NBR) and the general one of the Edinburgh & Glasgow Railway were both opened in 1846, with the third, Canal Street station, opened a year later, serving the Edinburgh, Leith & Granton Railway. The latter went under Princes Street and St Andrew Square to Scotland Street and involved hauling the train with ropes through a long inclined tunnel. The line connected the city with the ports on the Firth of Forth.

When the Forth Rail Bridge opened in 1890, rail traffic increased and a major expansion of Waverley station took place between 1892 and 1900.

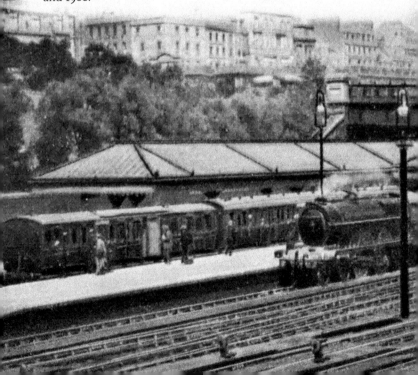

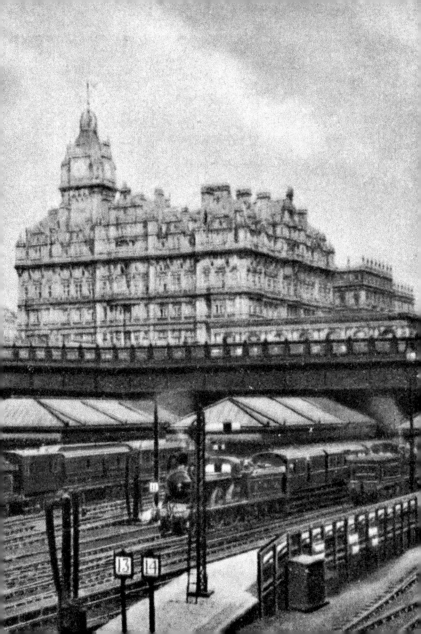

19. PRINCES STREET

The first suggested name for Princes Street was St Giles' Street, after the patron saint of Edinburgh, and there was a proposal, thankfully declined, to build on both sides of the street. Construction of three-storey houses began at the east end and had reached Hanover Street by 1786, Frederick Street by 1795 and completed at the west end in 1805. Edinburgh citizens warmed to the promenade and particularly liked the open view across the valley to Old Town and the castle.

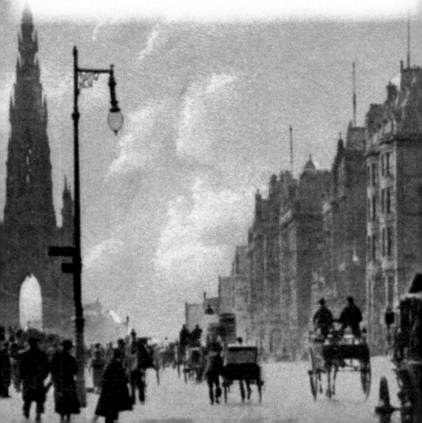

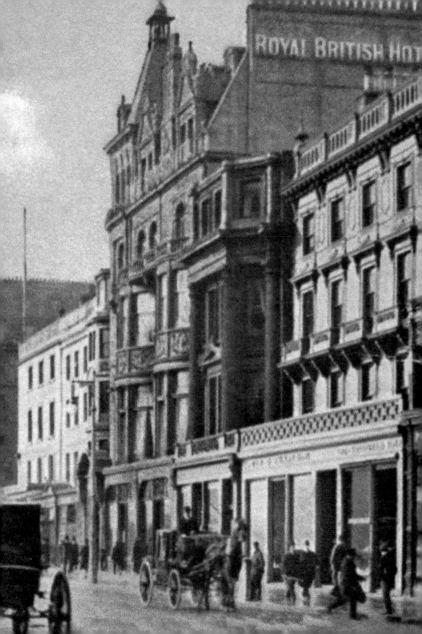

20. SCOTT MONUMENT

Sir Walter Scott, who died in 1832, was one of Scotland's greatest novelists and his legacy is commemorated by this 200-foot memorial, which, at that time, was the highest dedicated to any writer in the world. The designer was a self-taught draftsman and architect called George Meikle Kemp, who submitted his competition entry anonymously. Unfortunately, he drowned in the Union Canal only months before the inauguration in 1844.

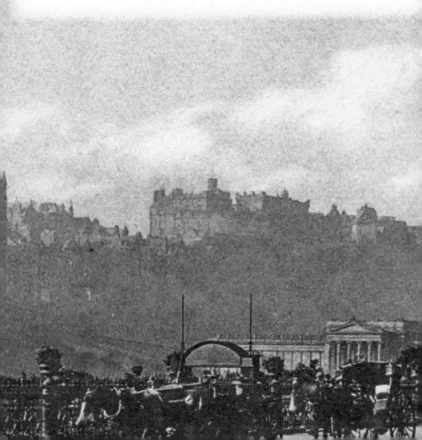

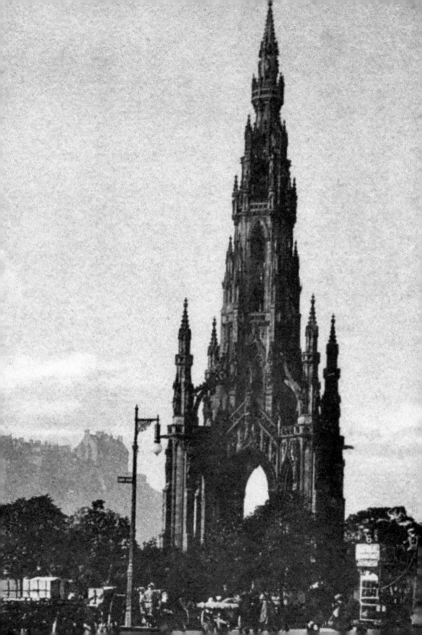

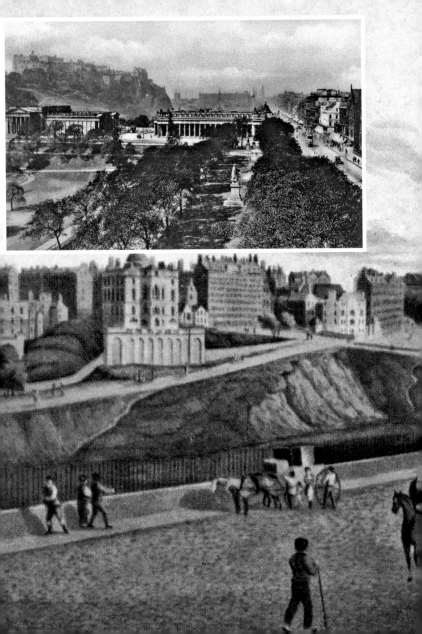

21. THE MOUND

Enormous quantities of earth were removed from the open land of Multrees Hill and Bearfords Park during the construction of Princes Street, and much was deposited in the swampy valley of the now-drained Nor' Loch. Inadvertently, this created a crossing from the Lawnmarket to the New Town, which was well used, especially after a local tartan seller placed stepping stones on the mud, forming a walkway nicknamed Geordie Boyd's mud bridge. From this humble beginning The Mound evolved. At its foot are the classical buildings of Royal Scottish Academy (1826) and the National Gallery (1854), both designed by William Playfair.

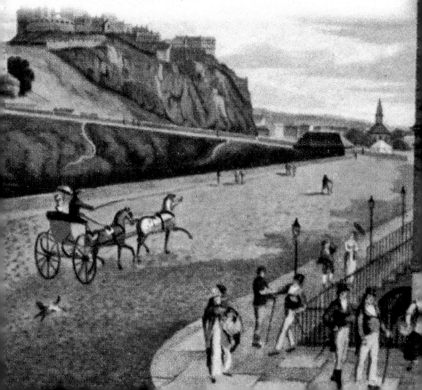

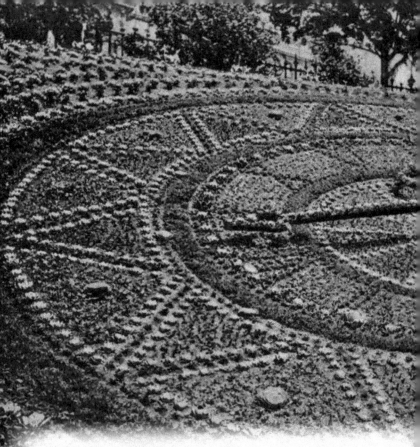

22. THE FLORAL CLOCK

By 1903, Princes Street Gardens were established as an important public amenity, tended by full-time gardeners. The superintendent at that time was an innovative man, John McHattie, who started the idea of a floral clock. The mechanism for movement was salvaged from Elie Church and hidden within the nearby statue of Allan Ramsay; it needed to be wound up every day. It captured the imagination of the public and has been copied throughout the world.

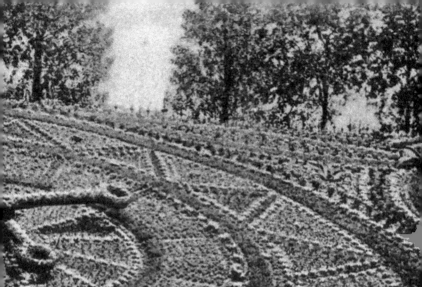

23. ST JOHN'S EPISCOPALIAN CHURCH

In 1818, thirteen years after Princes Street was completed, twenty-five-year-old architect William Burn saw the beautiful structure he had designed grace the western corner of the gardens. St Cuthbert's Church behind it was founded 700 years earlier. The trees and gardens in the painting belonged to the mansion of Kirkbraehead, all of which was swept away in 1869 for the Caledonian railway station and its associated hotel.

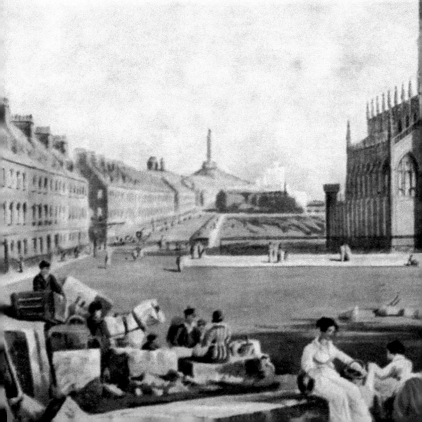

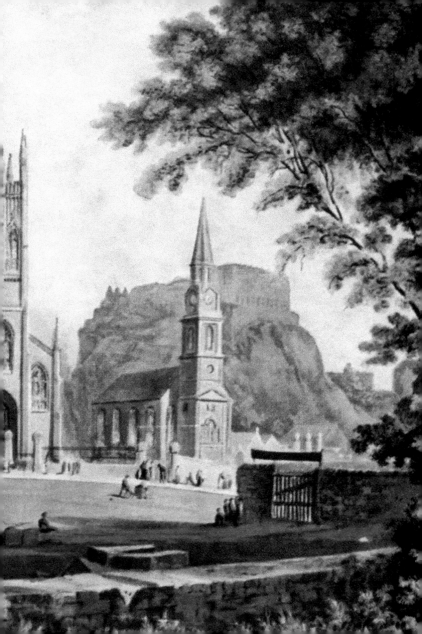

24. KINGS STABLES ROAD

This thoroughfare, which led to the Grassmarket, ran along the south bank of the Nor' Loch. Between the road and the water was a farm, market garden, orchards and stables to serve the royalty. The watchtower on the left guarded the graveyard of St Cuthbert's Church. These lookout posts became commonplace in the early nineteenth century in response to bodysnatchers, who were paid to provide cadavers to Edinburgh Medical School for teaching anatomy. The notorious case of Burke and Hare still fascinates us.

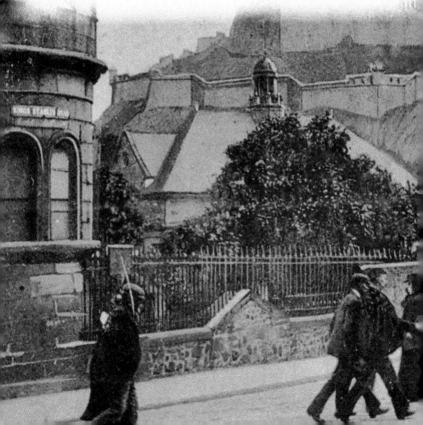

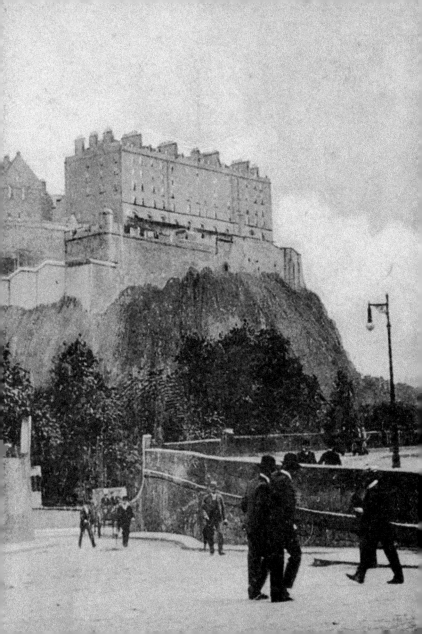

25. GRASSMARKET AND CASTLE

Below the southern face of Castle Rock is the community of Grassmarket, once a suburb of medieval Edinburgh and the main marketplace for livestock and grain. After the Battle of Flodden in 1513, a defensive city wall (Flodden Wall) was built, enclosing Grassmarket within it and entered through the West Port. At the opposite end, the steep lane of West Bow led up to Lawnmarket. The jutting gables and windows of the houses lining this street on either side only exaggerated the narrowness. It was a dark, atmospheric place riddled with tales of strange goings-on.

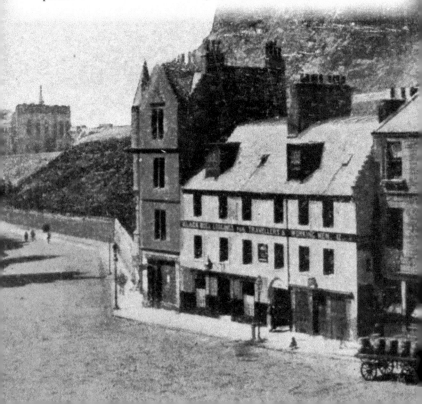

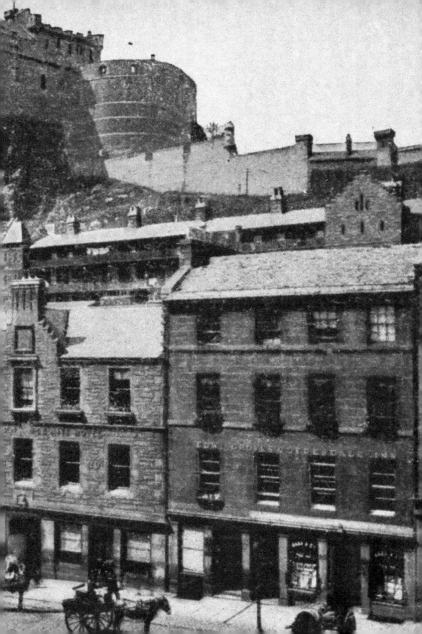

26. THE GRASSMARKET

The numerous inns and alehouses lining the cobbled rectangle meant the Grassmarket was always a bustling, lively place, but it became particularly rowdy when executions took place as they did from 1660 for over 100 years. Wretched prisoners were brought from the stinking Old Tolbooth, followed by crowds of onlookers, and riots were not uncommon. A gibbet shape has been laid in the pavement next to the memorial to the Covenanters, many of whom were hanged here.

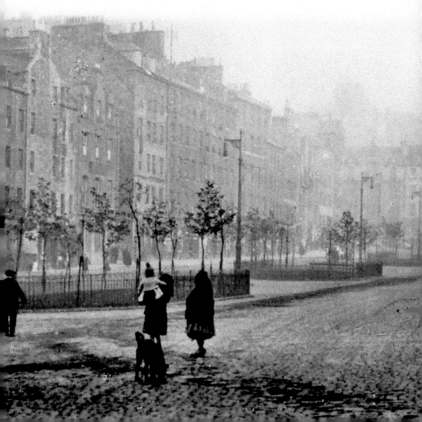

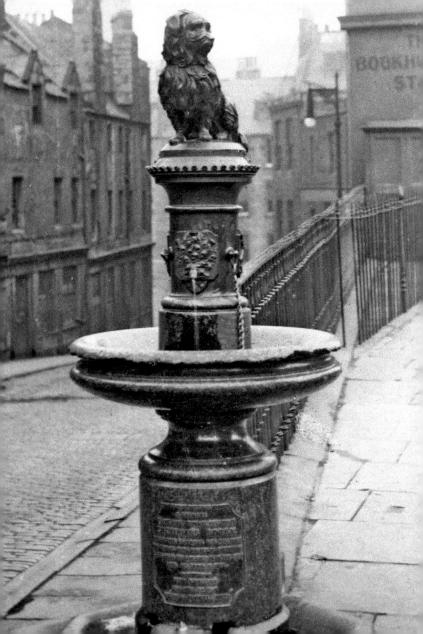

27. GREYFRIARS BOBBY

The story of this loyal terrier refusing to leave his master's grave is universally known and loved. The life-size statue and fountain were erected in 1872 with a granite water basin at the foot, presumably for canine refreshment. The inn named after the dog is at the top of Candlemaker Row, a steep hill leading to the Grassmarket. The dog's owner is buried in the graveyard of Greyfriars Kirk, along with many other Edinburgh luminaries.

28. MCEWAN HALL

The University Medical School in Teviot Place was built between 1876 and 1886, but when it was completed there were insufficient funds for the planned graduation hall. William McEwan, philanthropic brewery owner and politician, came to the rescue and paid for this splendid building with distinctive ribbed dome and ornate interior, which emulates a Greek theatre. The Students Union on the left dates from 1889, and is built in sixteenth-century style.

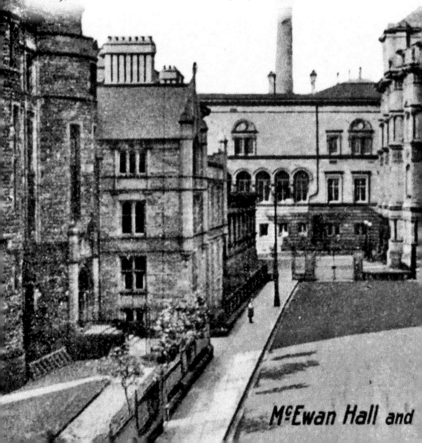

McEwan Hall and

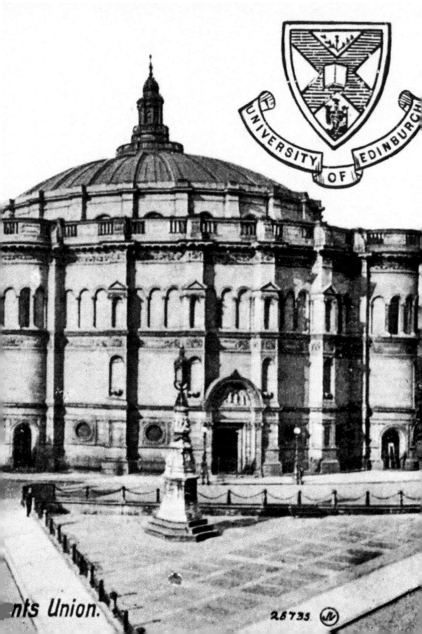

nts Union.

UNIVERSITY OF EDINBURGH

26735

29. ROYAL INFIRMARY

The large green space to the south of Old Town was once filled with water of the Burgh Loch, which was drained in the eighteenth century, creating the public amenity of The Meadows. The Royal Infirmary dominates the northern fringe. The original hospital was in a house off the Cowgate before moving in 1738 to larger premises in Infirmary Street. The attractive Victorian Royal Infirmary opened in 1879 and was used until 2002, when it transferred to Little France.

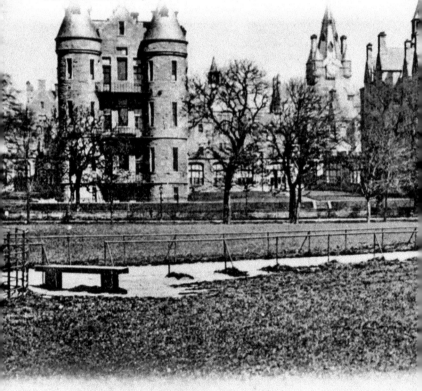

Royal Infirmary, Edinburgh Printed by V

Infirmerie royale.

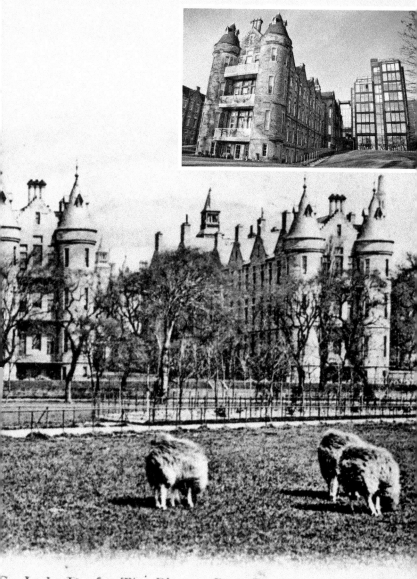

30. MIDDLE MEADOW WALK

The wide path between the Medical School and the Royal Infirmary links The Meadows to the town. On the eastern side of the walkway is George Square, with cobbled roads surrounding a central wooded garden. In 1776, when the overpopulated Old Town was bursting at the seams, this was the first housing development outwith the city walls. The dwellings were highly desirable and purchased by, among others, Henry Dundas, Walter Scott and Sir Arthur Conan Doyle.

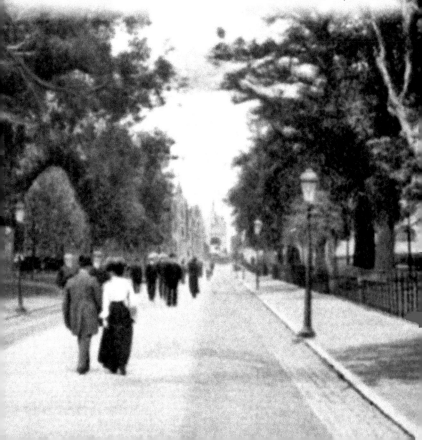

31. OLD SURGEONS' HALL

The Royal College of Surgeons dates back as far as 1505, at which time membership included barbers. The first hall was in Surgeons' Square and from where Dr Robert Knox, pioneer of his day, employed the services of William Burke and William Hare to obtain dead bodies for dissection.

The museum at Old Surgeons' Hall displays a fascinating, and often grisly, collection of pathological specimens and terrifying instruments. It is sobering to remember that James Young Simpson did not discover anaesthetic until 1847!

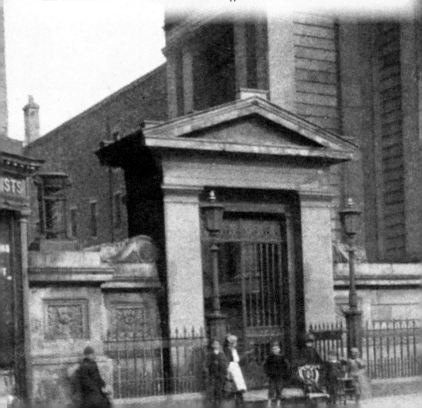

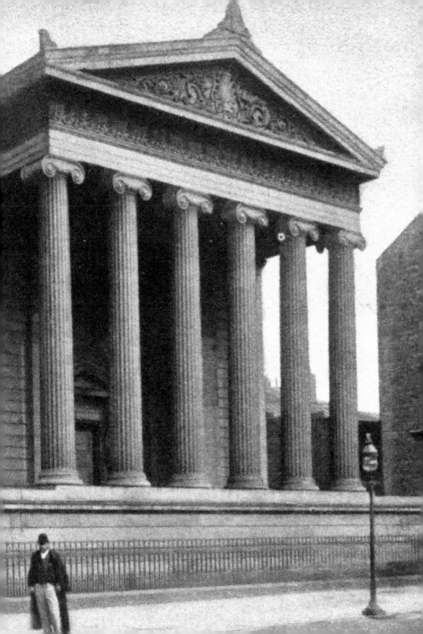

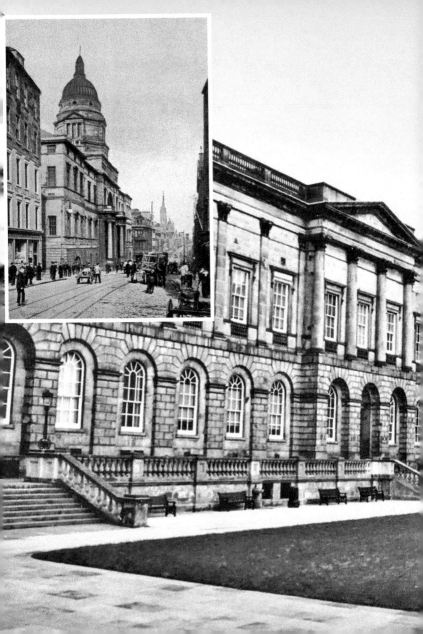

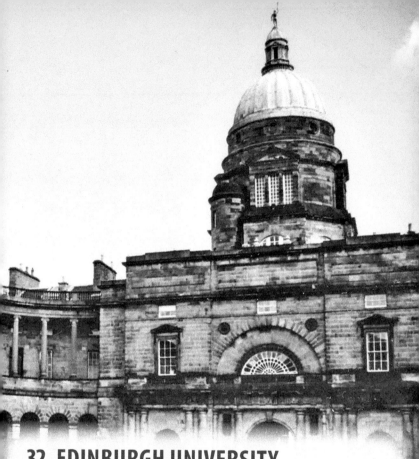

32. EDINBURGH UNIVERSITY

The site on which Old College was built was Kirk O' Field, a name etched into Edinburgh's history as the place where Lord Darnley, husband of Mary, Queen of Scots, was murdered in 1567. After the Reformation, James VI granted a charter to provide a college to teach humanities and theology, which took place in the old ecclesiastical buildings. The present quadrangle and monumental façade was completed in 1820.

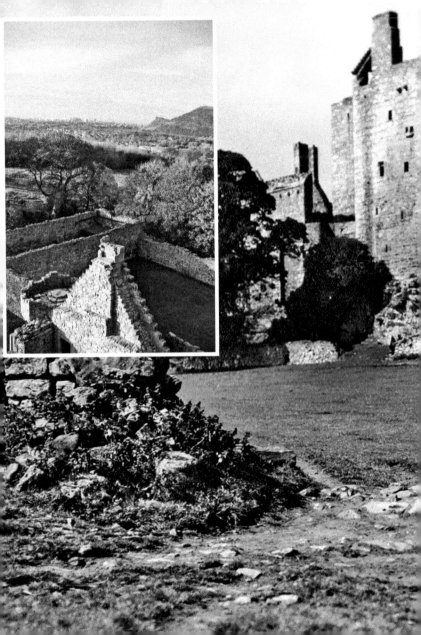

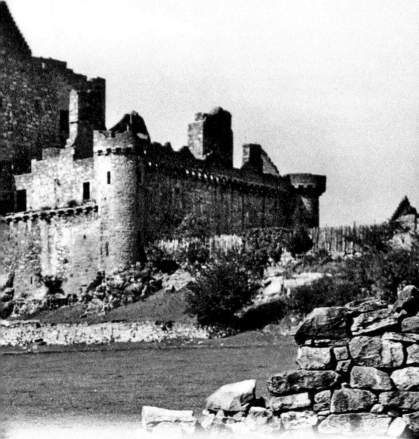

33. CRAIGMILLAR CASTLE

This splendid fortification on a rocky promontory has, at its core, a fifteenth-century tower house, thought to be similar to David's Tower on Edinburgh Castle. Mary, Queen of Scots favoured it as a country retreat, particularly after events in 1566. Earlier that year, her trusted aide David Rizzio was murdered in Holyrood Palace shortly before she gave birth to her son (the future James VI of Scotland), while her marriage to husband Lord Darnley remained turbulent.

34. GEORGE STREET

The plan submitted by James Craig won the competition to design a New Town for Edinburgh in 1766 to solve the problem of the filthy, crumbling and overcrowded Old Town. Central to the linear layout was a wide thoroughfare punctuated at either end by open squares around gardens. The 115-foot-wide street was named after George III. The orderly elegance of New Town was in marked contrast to the chaos and squalor of the Old Town, and was quickly embraced by the wealthy and intelligentsia.

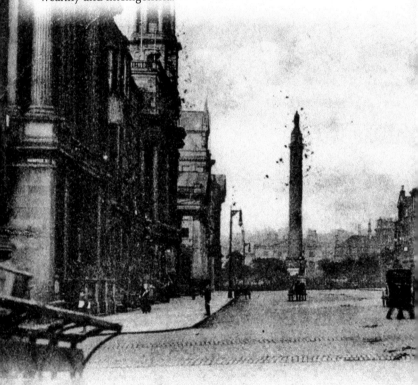

George Street, Edinburgh.

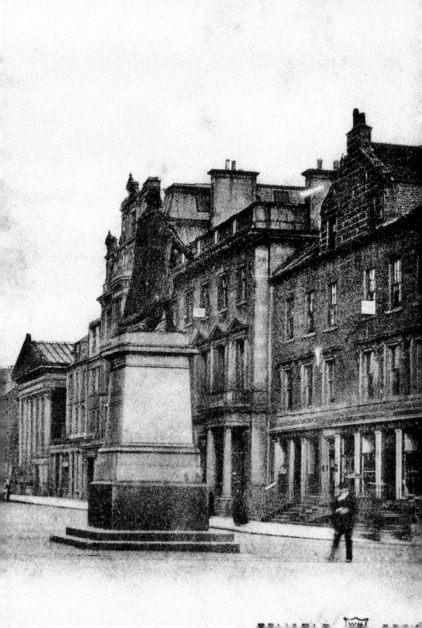

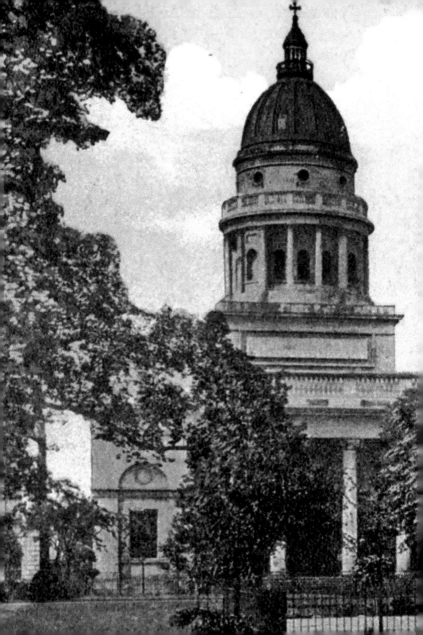

35. CHARLOTTE SQUARE

The neoclassical architecture of Robert Adam created beautiful palace-like façades around the central garden, epitomising the elegant image that Edinburgh wished to portray. It quickly became the most prestigious address in the New Town. It was initially named St George Square, after the patron saint of England (the eastern one being St Andrew Square), but after George IV came to the city in 1822, it was renamed after his wife, Charlotte. The central gardens are used as the venue for the annual Edinburgh Book Festival.

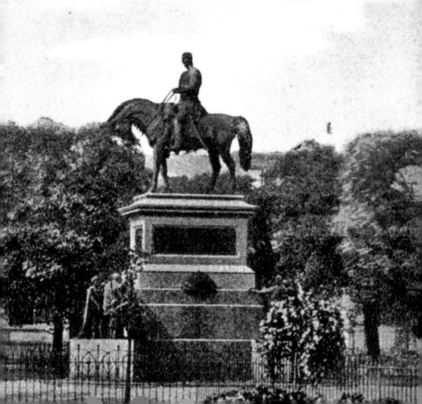

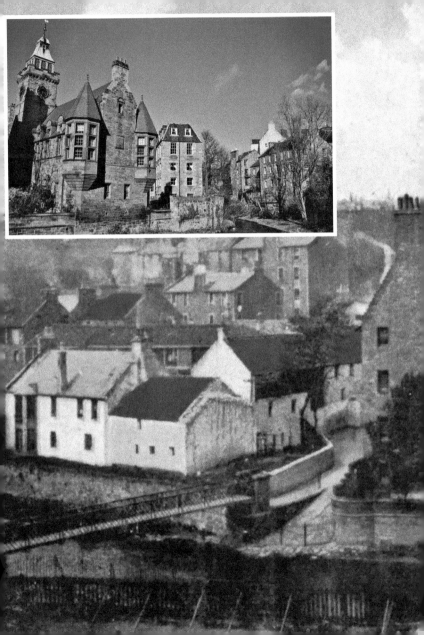

36. DEAN VILLAGE

The village is now overshadowed by the stylish tenements of the crescents of New Town, but the community has existed independently since the twelfth century, nestling in the steep-sided valley of the Water of Leith. At its industrial height there were eleven working mills. It was approached by a narrow winding lane leading over a small stone bridge, which was the main route for all who were travelling west. During the early 1800s, industries other than water and flour mills were established, notably tanning, blacksmiths and textiles.

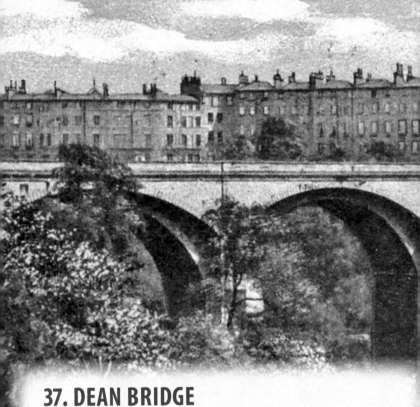

37. DEAN BRIDGE

The 100-foot-high bridge spanning the steep valley of the Water of Leith was the work of Thomas Telford and was built in 1831. Apart from by-passing the bottleneck of Dean Village and allowing easier access to routes northwards, it facilitated further expansion of the New Town. The bridge probably accelerated the inevitable decline of the old industries as Edinburgh modernised during the twentieth century. However, in the 1970s buildings were renovated and Dean Village became a desirable place to live.

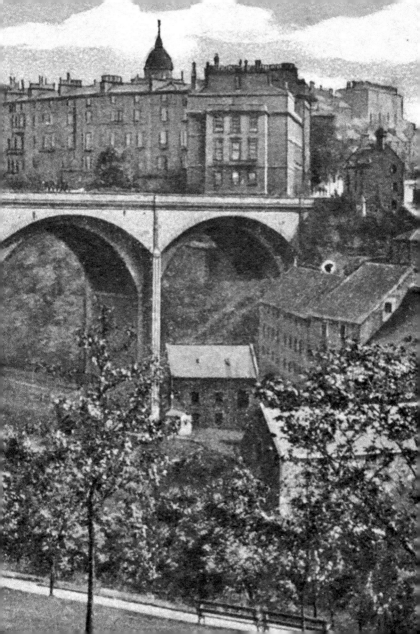

38. ST BERNARD'S WELL

Downstream from Dean Village, the Water of Leith flows through a gorge. On the high ground to the right are the New Town crescents of Moray Place and Ainslie Place, below which St Bernard's Well is found. Discovered in 1760, it was believed to have therapeutic effects. One local convert was Lord Gardenstone, who purchased the well and commissioned Alexander Naesmyth to design a temple around a statue of the goddess Hygeia, emulating the one in Tivoli.

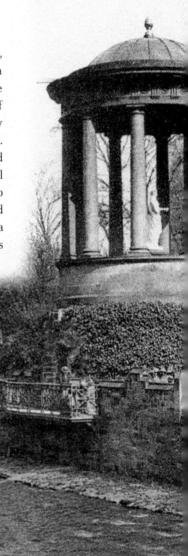

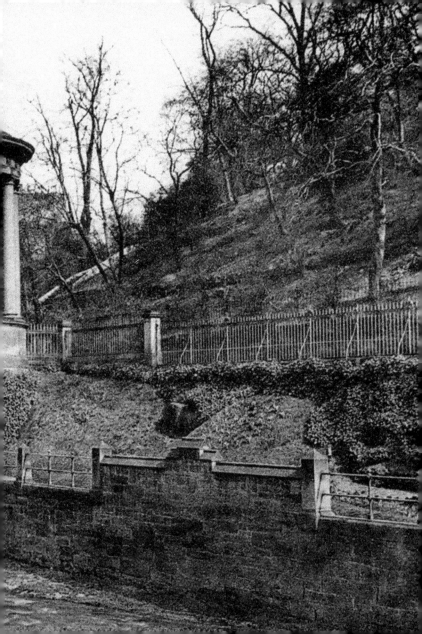

39. STOCKBRIDGE

This community on the Water of Leith was based upon farms, mills and tanneries until the nineteenth century. The steep approach from Edinburgh entailed fording the water or crossing a small wooden footbridge, both of which were dangerous when the river was in spate. In 1786, a new stone bridge was built, ultimately being replaced by the current one in 1901. New Town expansion gradually swallowed up the village, although it does retain an independent identity and the many quirky shops give it a bohemian atmosphere.

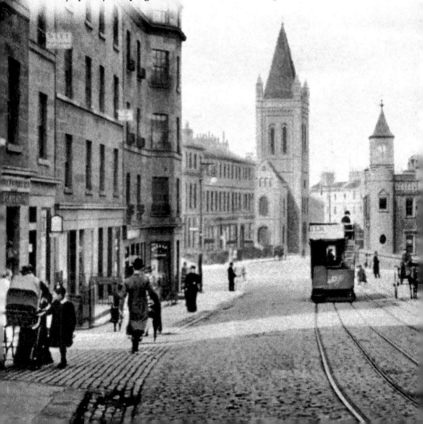

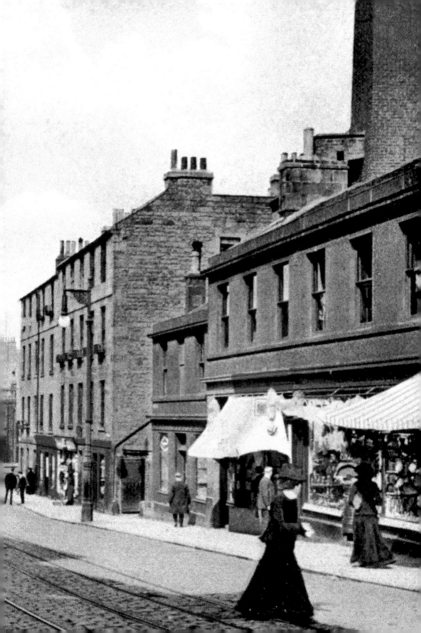

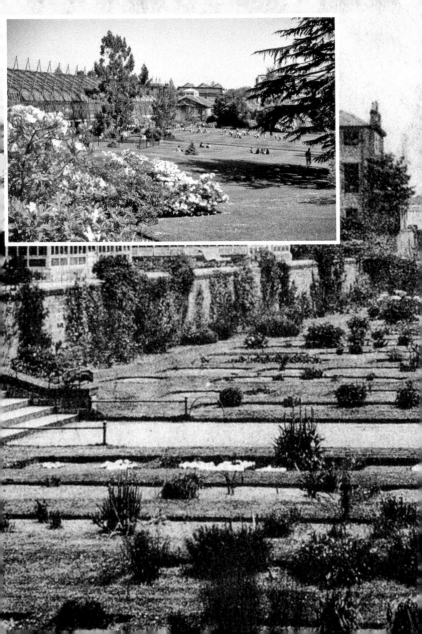

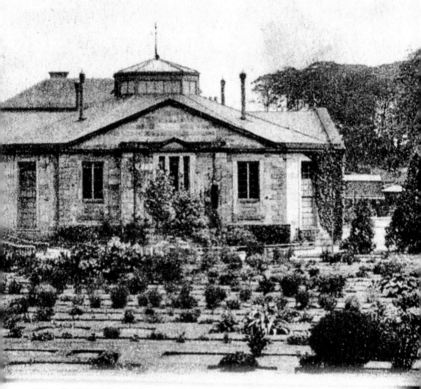

40. ROYAL BOTANIC GARDENS

This important public amenity, created around Inverleith House, is the fourth location in its history. The first in Scotland was a Physic Garden covering a small area near Holyrood Abbey, started in 1670. That was moved to a larger site where Waverley Station now stands before relocating to a field between Edinburgh and Leith (the current Haddington Place). Eventually, in 1820, the gardens began at Inverleith. Transferring mature trees proved difficult but a contraption was devised by the curator, William McNab, to facilitate this task.

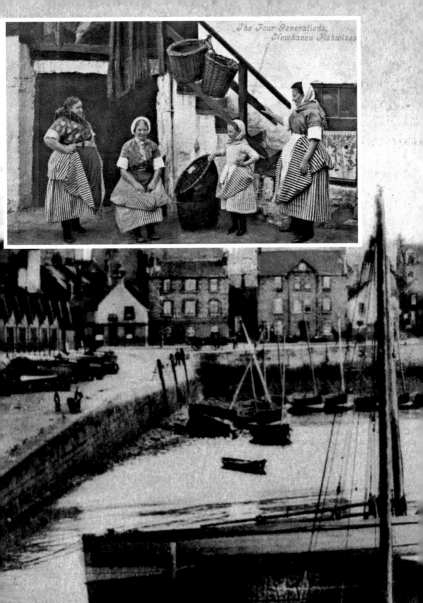

The Four Generations,
Newhaven Fishwives

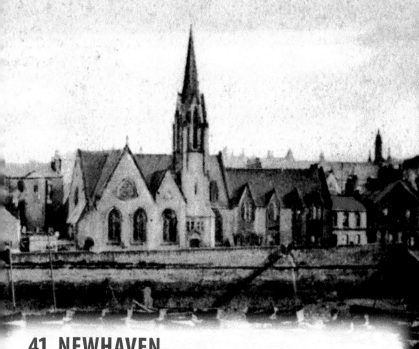

41. NEWHAVEN

This fishing village on the Firth of Forth, a mere 2 miles from Old Town, was an independent community from its founding in 1488 until integrated into the city of Edinburgh in the twentieth century. In 1505, James IV commissioned the dockyard to build the *Great Michael* to head the Scottish Navy. She was launched in 1511 but due to the king's death and the high number of nobility killed at the Battle of Flodden in 1513, the ship was sold to France.

The Newhaven fishwives were known countrywide for their distinctive attire and feisty disposition.

42. BERNARD STREET BRIDGE, LEITH

Leith became the port of Edinburgh in the fourteenth century. The land to the east of the river belonged to Logans of Restalrig, but Holyrood Abbey owned the land to the west; a charter was drawn up from Edinburgh to prevent Leith inhabitants from trading on their own account. The first three-arched stone bridge joining the two sides was built in the fifteenth century (at present-day Sandport Place), but by the eighteenth century it was an impediment to the movement of ships and to the development of the harbour, so was replaced by the Lower Drawbridge just downstream from Bernard Street Bridge in 1778. It was demolished in 1910, but by this time the Victoria Swing Bridge, the largest of its type in Britain, had been constructed, carrying two rail tracks and a road.

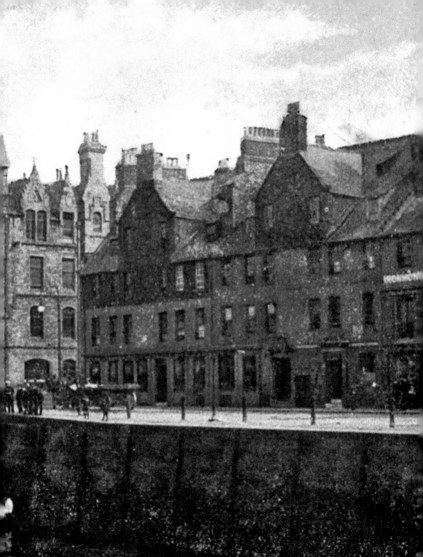

BERNARD STREET BRIDGE, LEITH.

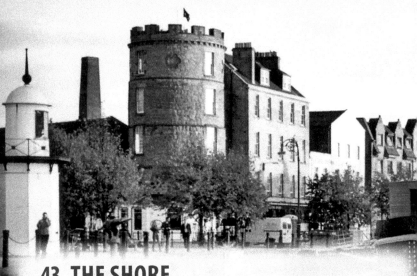

43. THE SHORE

The Shore was, for centuries, the quayside of the natural harbour at the mouth of the Water of Leith, but the name is now synonymous with high-end catering. Leith's history is a rich tapestry of maritime trading, shipbuilding, whaling, whiskey production, glassmaking and royal associations, particularly with Mary of Guise during the Seige of Leith in 1548. However, after the Second World War, the area fell on hard times as shipyards closed, railway services were withdrawn and industries declined, and it became known for crime, prostitution and drugs. In the 1990s, Leith began to reinvent itself as historic buildings, including warehouses, were renovated. The Seamans Mission was transformed to the luxury Malmaison Hotel and the Shore became famous for fasionable fish restaurants. Large housing developments along the waterfront have boosted Leith's economy in the twenty-first century.

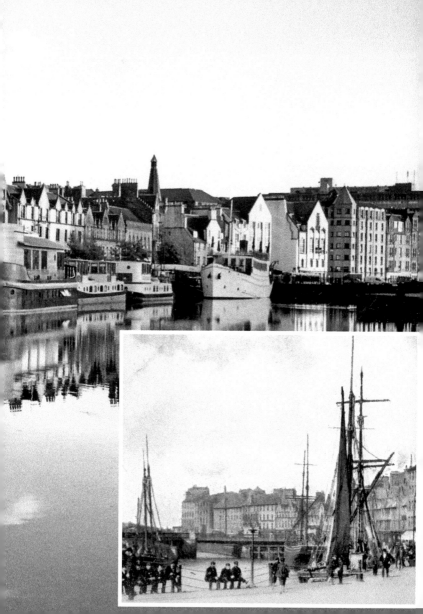

44. THE PIERS, LEITH

In the fourteenth century the port of Edinburgh at the mouth of the Water of Leith was little more than shelter and anchorage. By the eighteenth century, when more docks were required, it was realised that, unlike Newhaven, the water was too shallow and shifting sandbanks were hazardous. Various piers and breakwaters were tried before a major scheme of land reclamation was undertaken in the early 1800s. Many passengers heading to London and beyond would have embarked from these piers but only the bare bones of these old wooden structures remain, used as nesting sites for gulls and terns. Royal yacht *Britannia* is moored nearby.

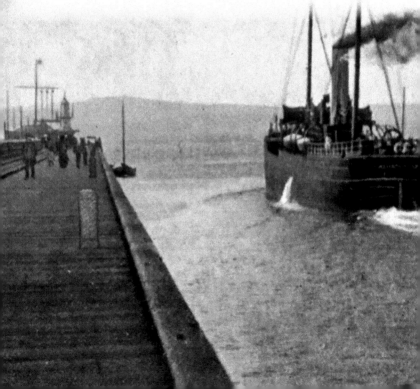

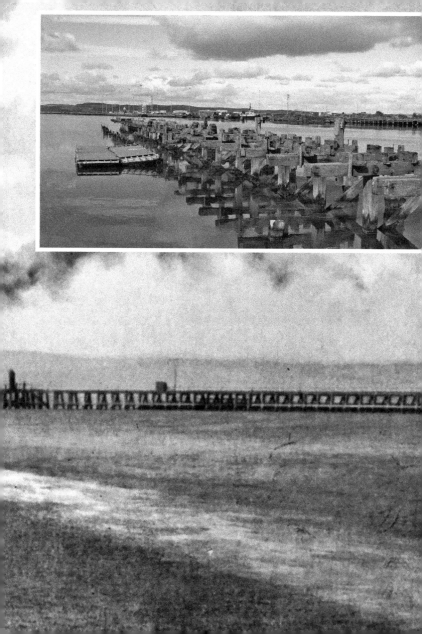

45. THE HARBOUR, LEITH

The docks and tidal harbour in the main picture had been developed from 1806 onwards to accommodate the increase in maritime trade. The Queens Dock was opened first. Subsequently, Victoria, Albert, Edinburgh and Imperial docks were created, and despite major development since then, many Victorian artefacts remain intact. In 1969, an enormous sea lock was constructed, which transformed the harbour to a deepwater port.

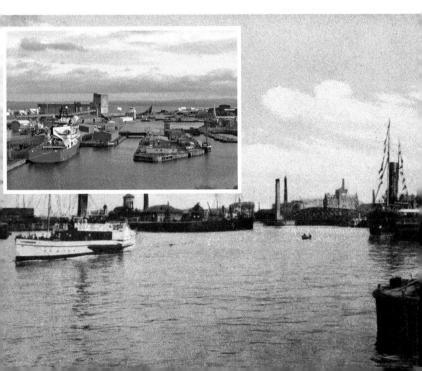